Medieval Tile Designs

Edited by

John Gough Nichols

DOVER PUBLICATIONS, INC.
Mineola, New York

Published in Canada by General Publishing Company, Ltd., 30 Lesmill Road, Don Mills, Toronto, Ontario.
Published in the United Kingdom by Constable and Company, Ltd., 3 The Lanchesters, 162–164 Fulham Palace Road, London W6 9ER.

Bibliographical Note

Medieval Tile Designs is a new work, first published by Dover Publications, Inc., in 1998. It reproduces designs from the work published by J.B. Nichols and Son, London, 1845. The Publisher's Note was prepared specially for this edition.

DOVER *Pictorial Archive* SERIES

Library of Congress Cataloging-in-Publication Data

Examples of decorative tiles, sometimes termed encaustic, engraved in facsimile, chiefly in their original size.
Medieval tile designs / edited by John Gough Nichols.
p. cm. — (Dover pictorial archive series)
Originally published: Examples of decorative tiles, sometimes termed encaustic, engraved in facsimile, chiefly in their original size. London : J.B. Nichols and Son, 1845.
Includes bibliographical references.
ISBN 0-486-29947-3 (pbk.)
1. Tiles, Medieval—England—Themes, motives. 2. Tiles—England—Themes, motives. 3. Decoration and ornament, Architectural—England. I. Nichols, John Gough, 1806–1873. II. Title. III. Series.
NA3543.A1E95 1998
738.6'0942—dc21
97-44799
CIP

Manufactured in the United States of America
Dover Publications, Inc., 31 East 2nd Street, Mineola, N.Y. 11501

PUBLISHER'S NOTE

In 1845 J.B. Nichols and Son, London, published a work entitled *Examples of Decorative Tiles, Sometimes Termed Encaustic, Engraved in Facsimile, Chiefly in Their Original Size* edited by John Gough Nichols, F. S. A. It was the editor's purpose to present the work "as a means of directing the attention of Architects to that mode of Pavement for Churches, particularly for Chancels and other open parts, which is most appropriate and accordant with ancient example; and which he was induced to suppose, would, if received in a correct spirit, be found at once decidedly beautiful and decidedly economical." Architects and craftsmen of the mid-nineteenth century did indeed find the designs in the book decidedly beautiful and designers and craftspeople of today will find them no less so. This volume presents 146 designs reproduced directly from a rare original edition of that work.

The ceramic tiles used to pave the floors of English cathedrals, churches, chapels, and monasteries from the eleventh through the fifteenth centuries were decorated with a rich variety of motifs (many of the designs in this volume come from churches of Winchester, St. Cross, Romsey, and Warblington). Included are floral and foliate designs, human and animal figures, and a vast array of geometric patterns. Most of the designs in this volume are worked in squares, as quadrants of circles within the four-sided format. A detail of the whole pattern, usually a quarter of the whole, is shown along with the complete tile pattern. Also included are a number of individual details and motifs.

The art and craft applications of these copyright-free designs are virtually limitless. They are ideal for fabric and wallpaper design, ceramic, wood burning, and even stained glass work. They reproduce extremely well right from the book or can be scanned into a computer for graphic art applications. They are also an ideal source of inspiration for design creation of your own.

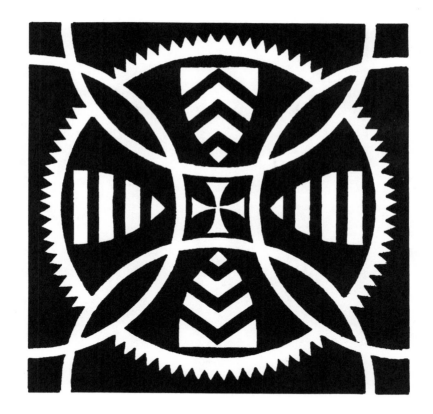

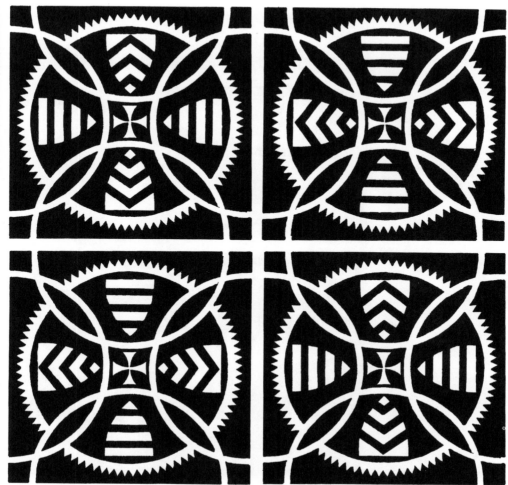

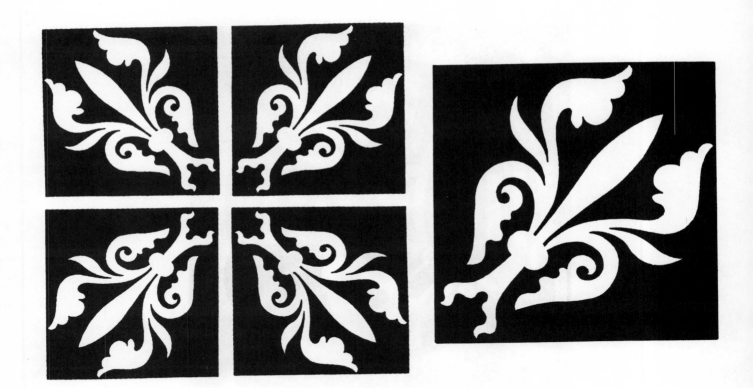

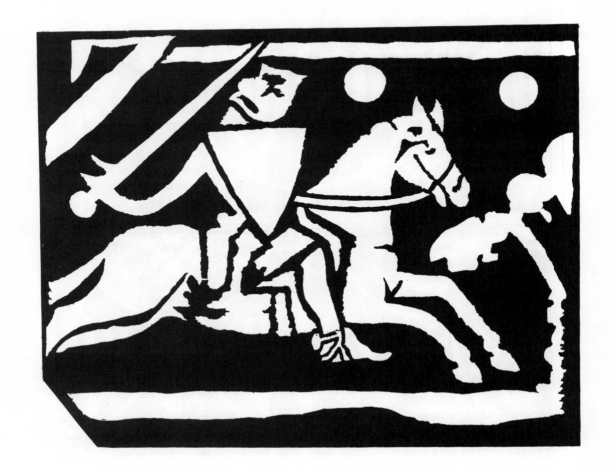

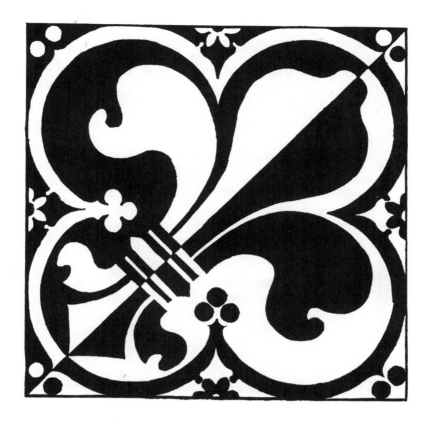

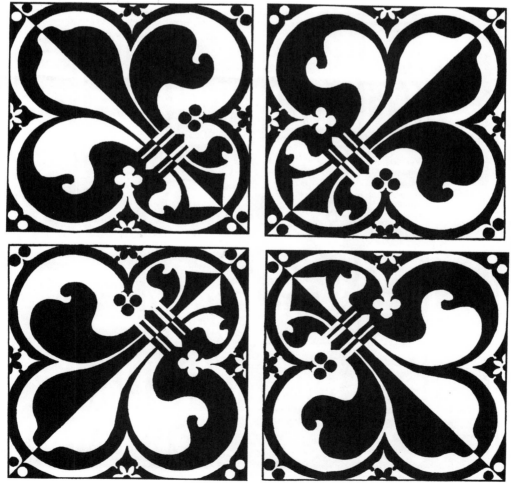

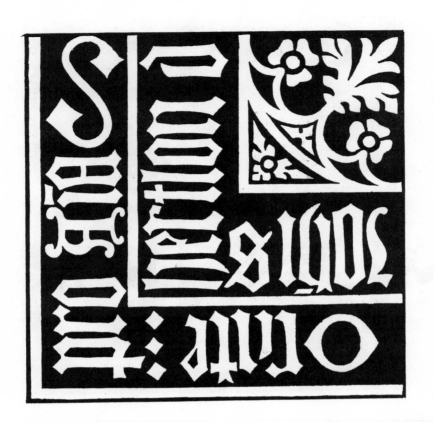

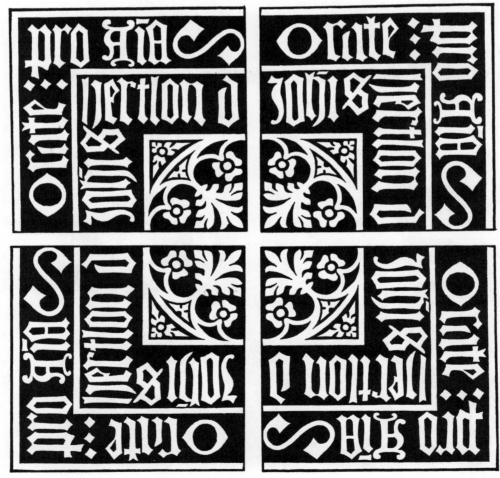

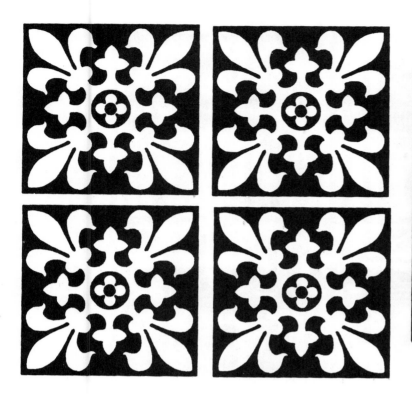
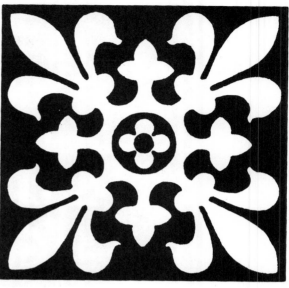
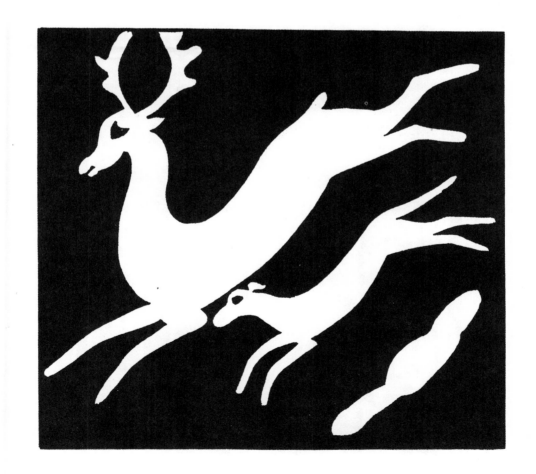

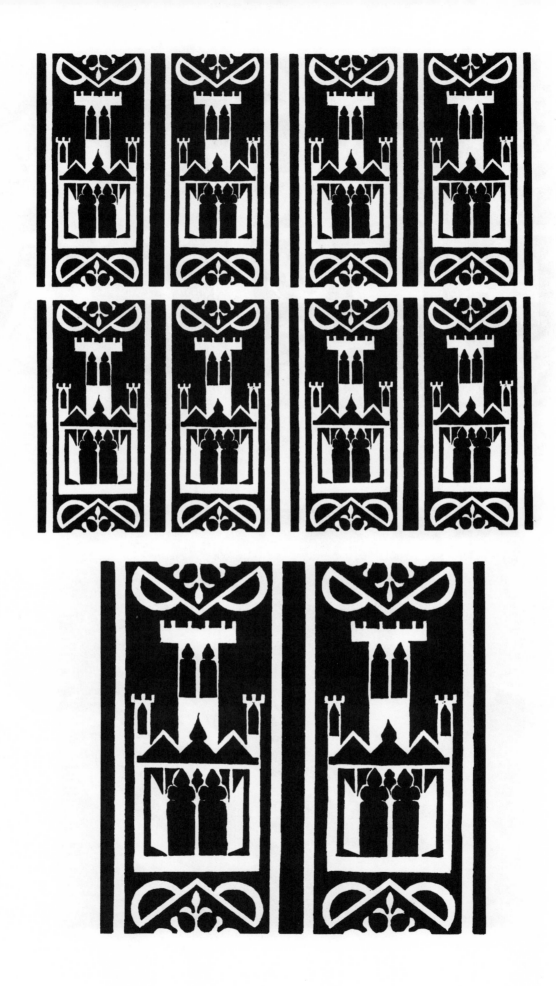

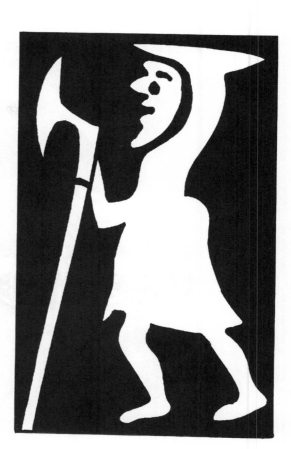

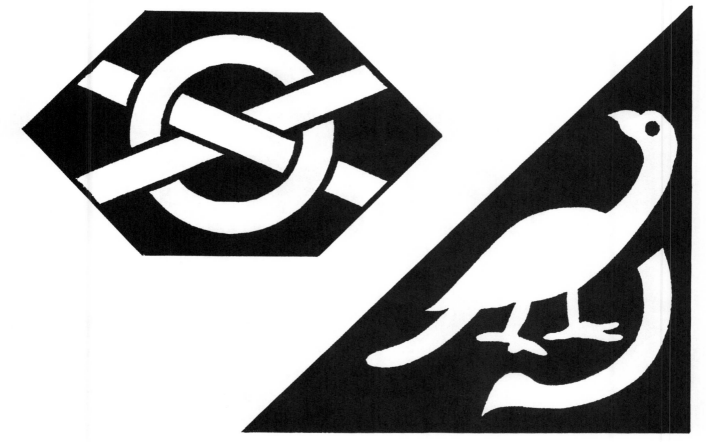

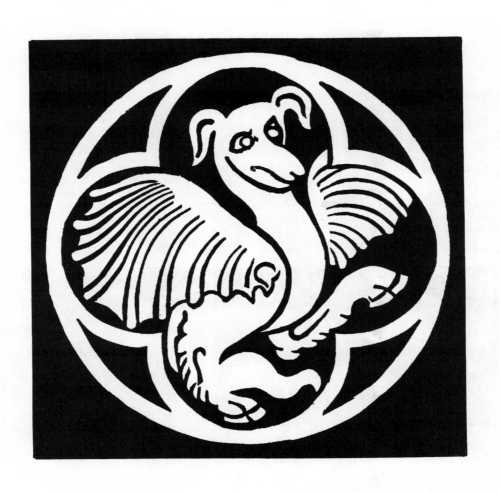

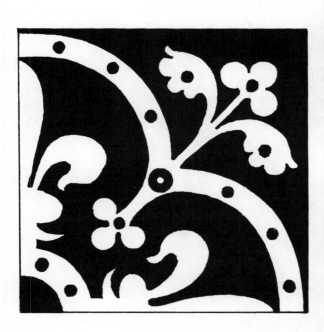

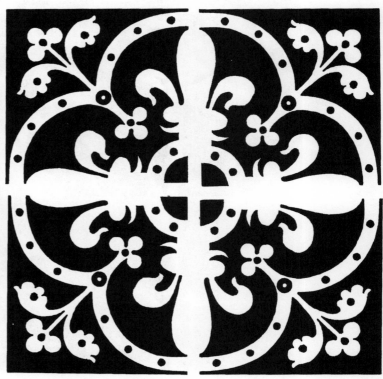

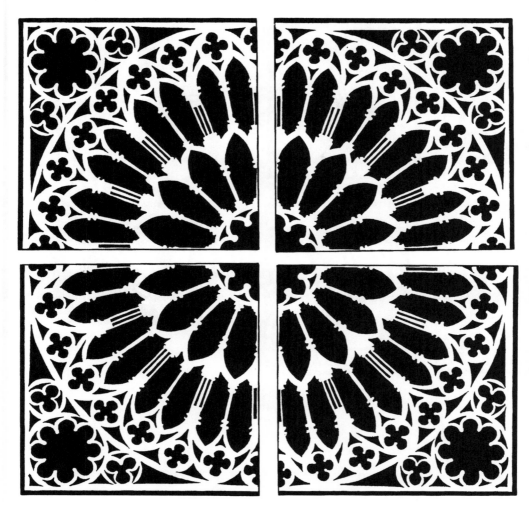

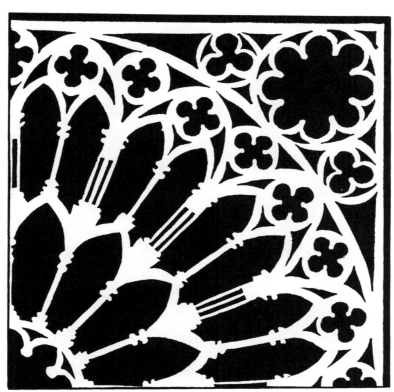

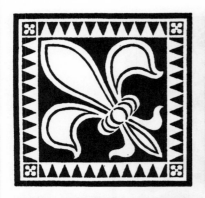
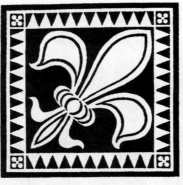

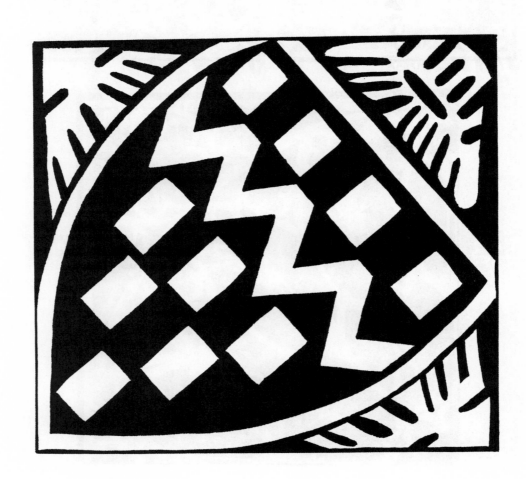

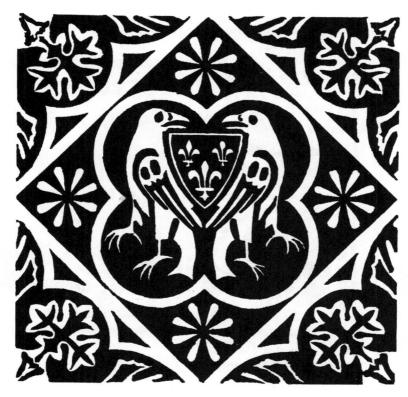

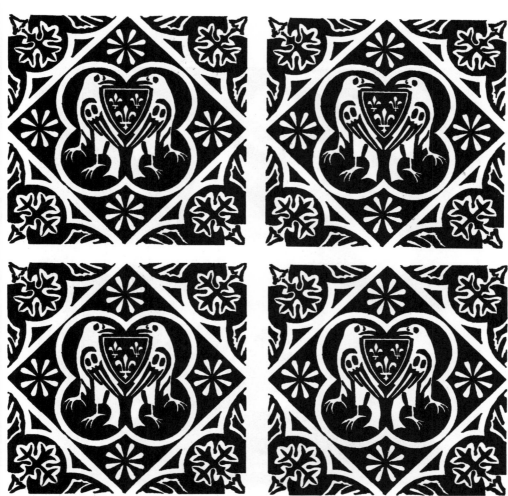

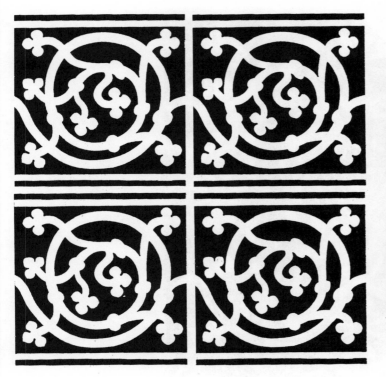

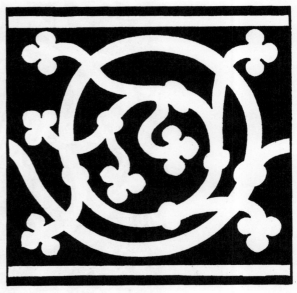

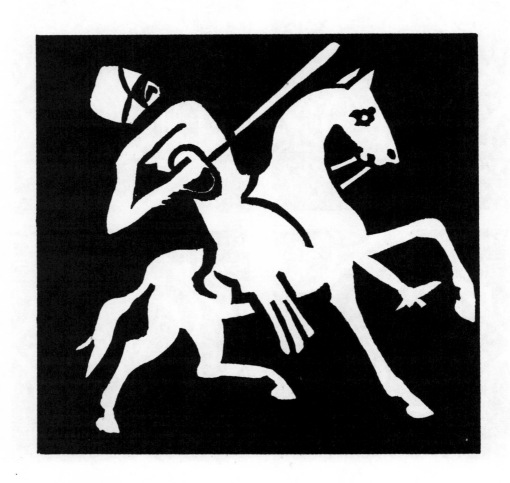

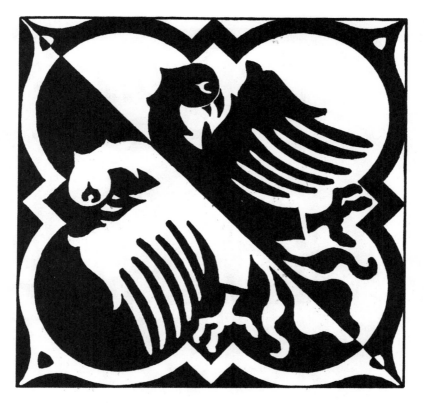

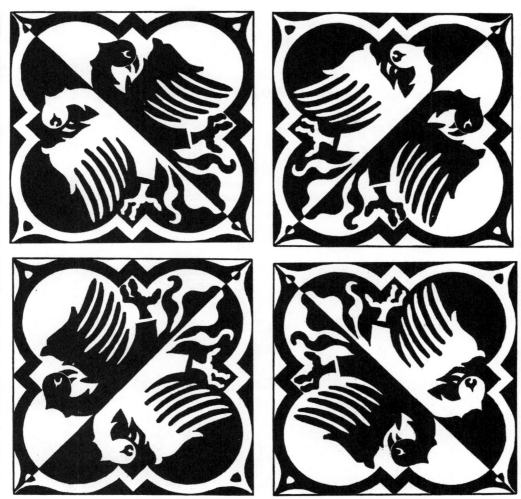

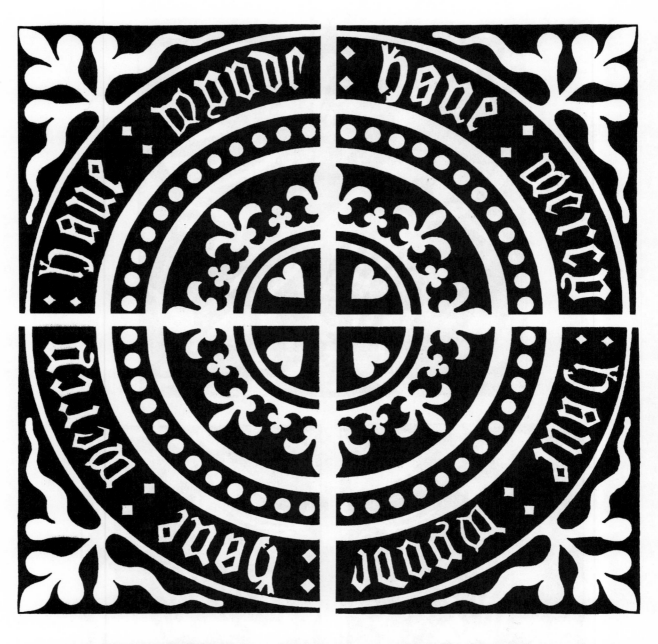

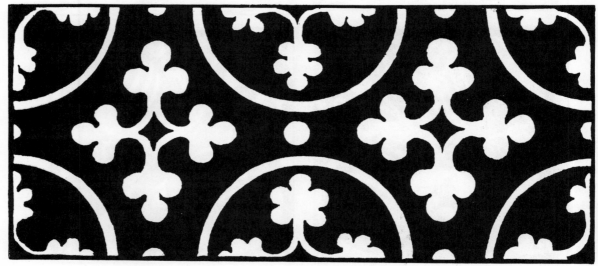

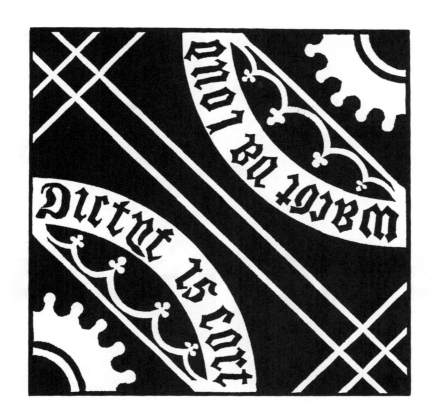

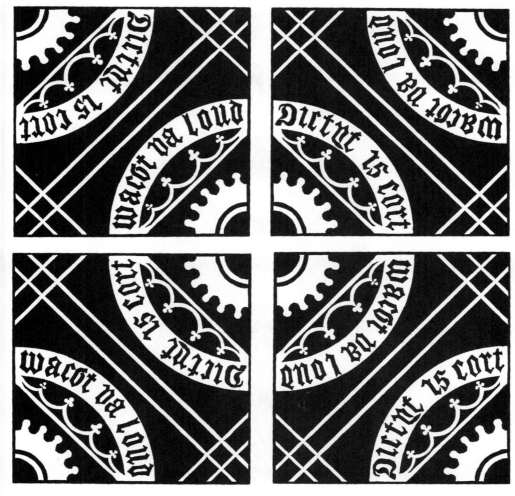

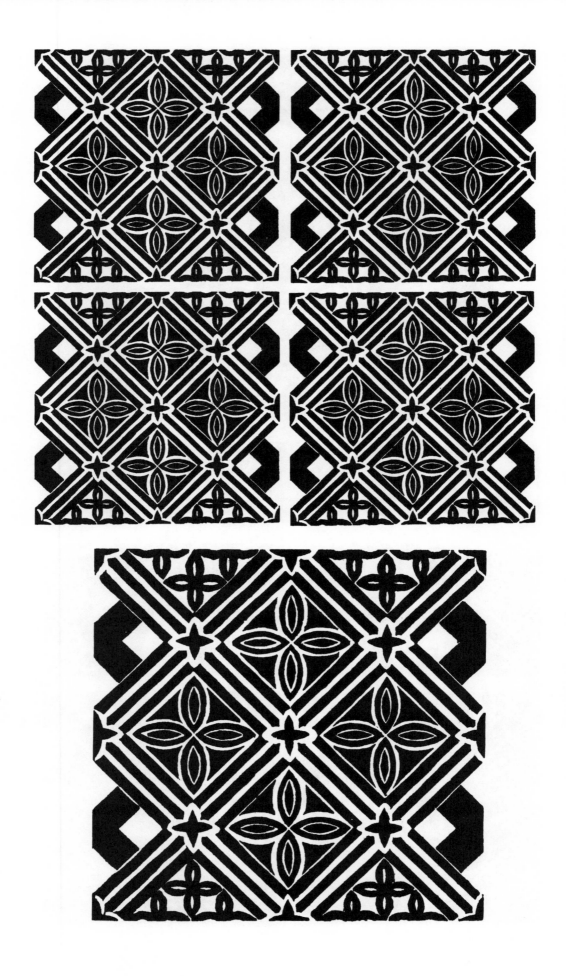

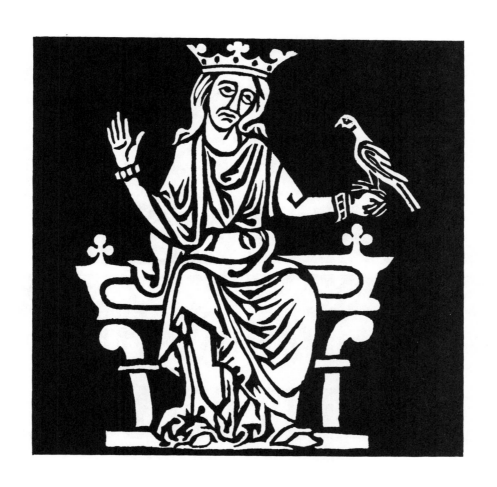

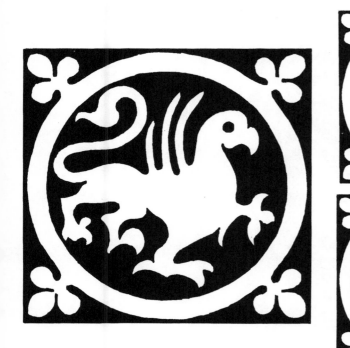

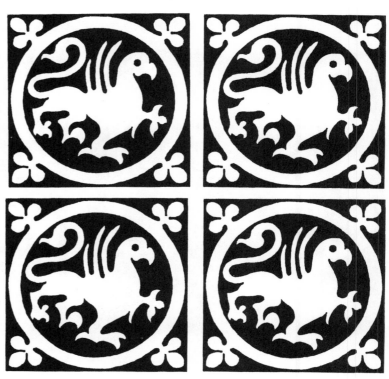

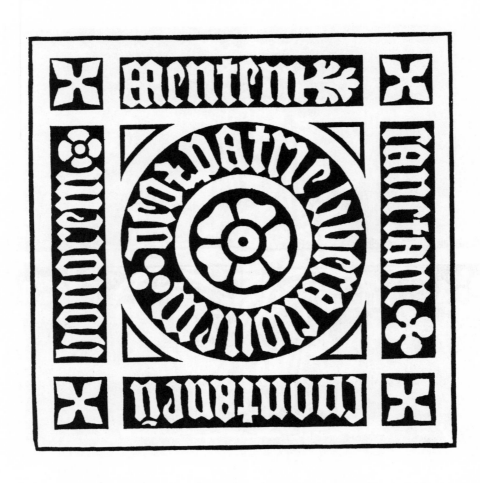

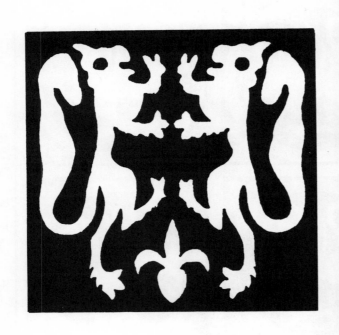

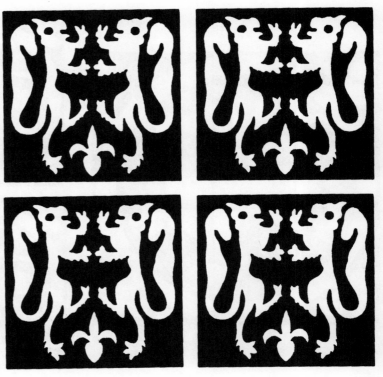

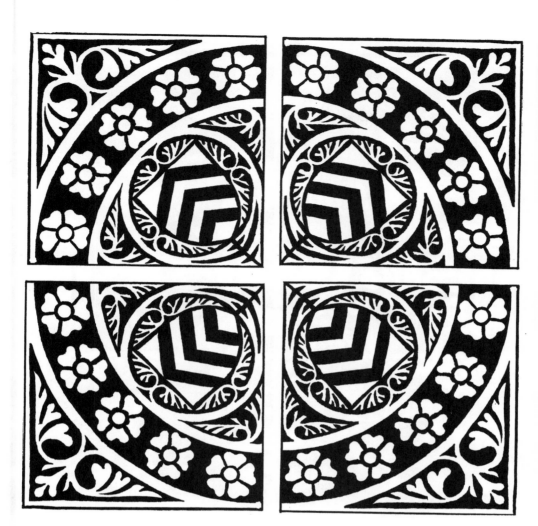

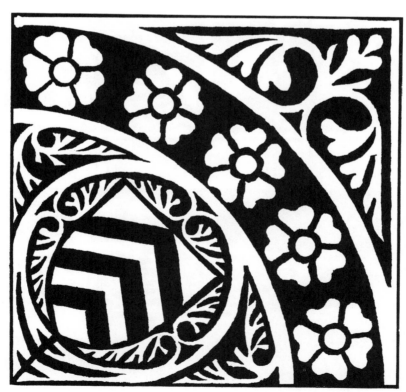

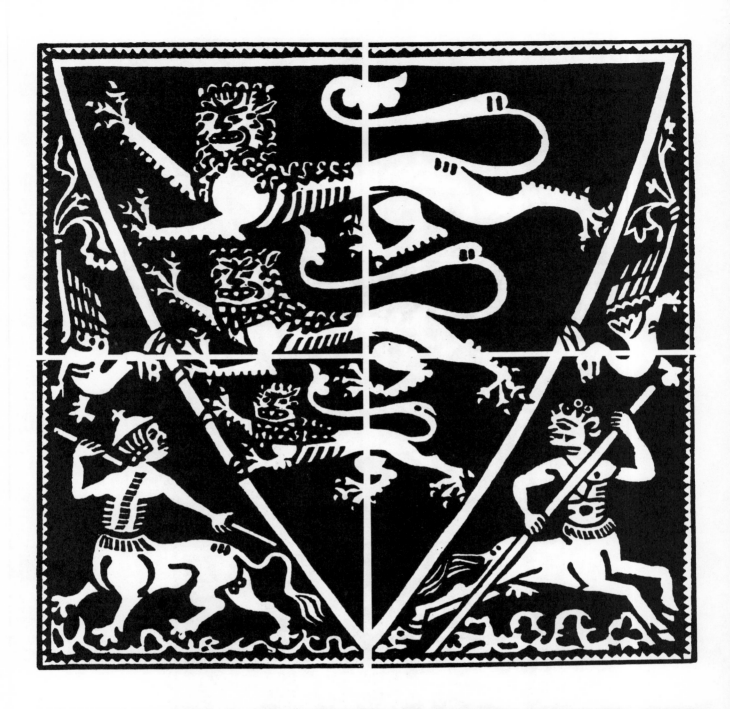

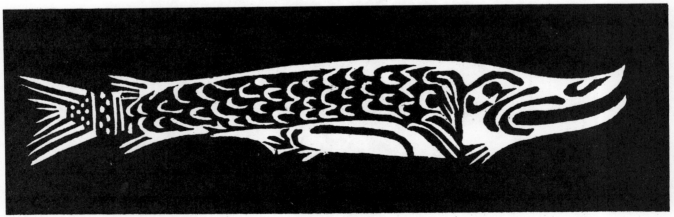

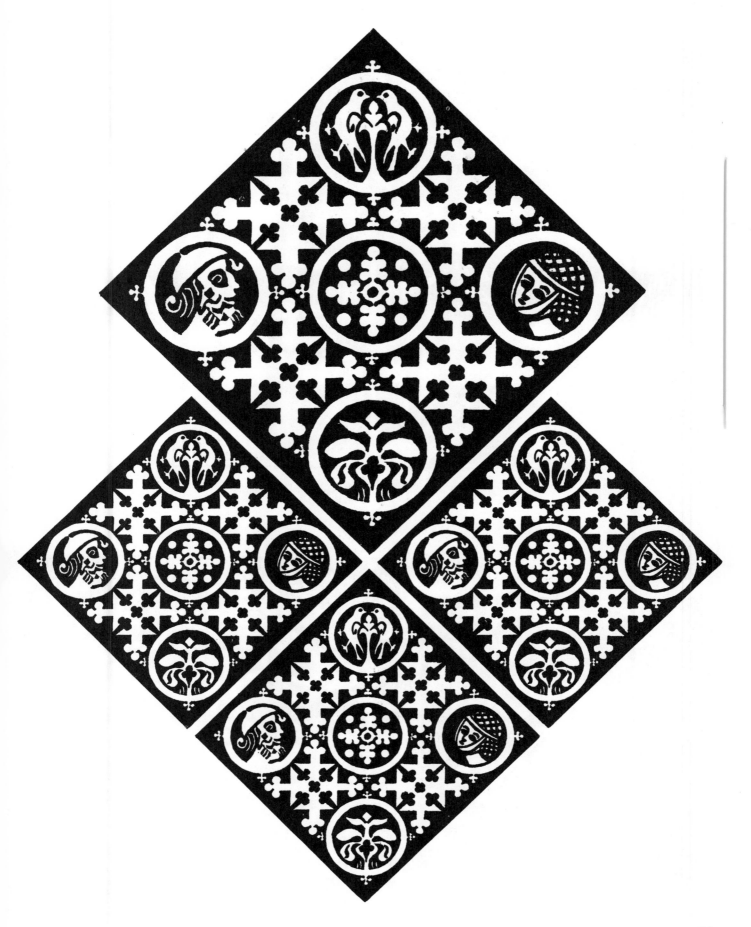

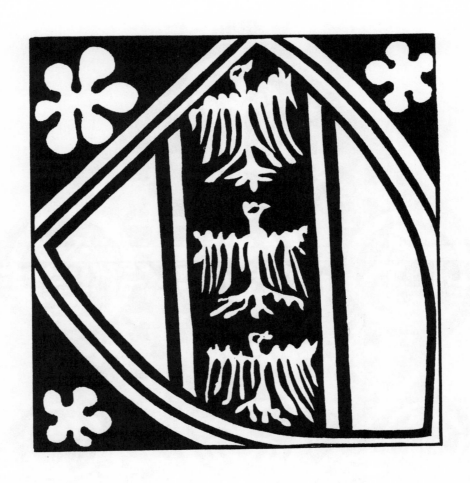

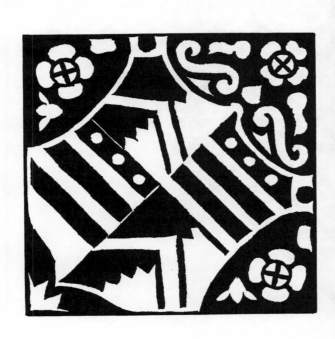

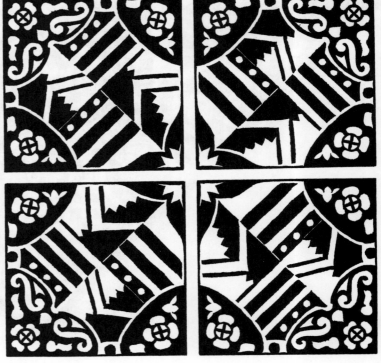

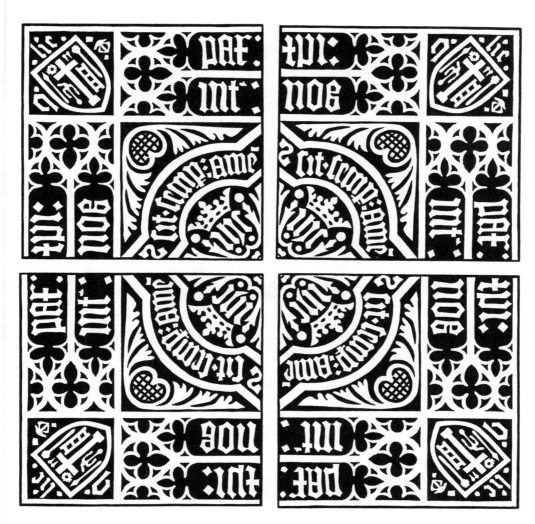

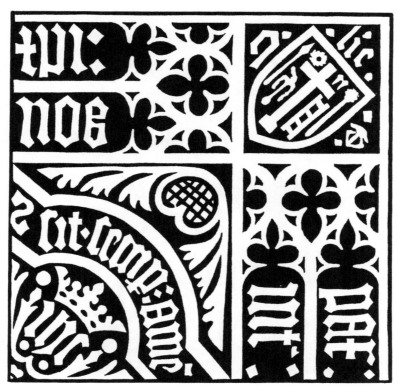

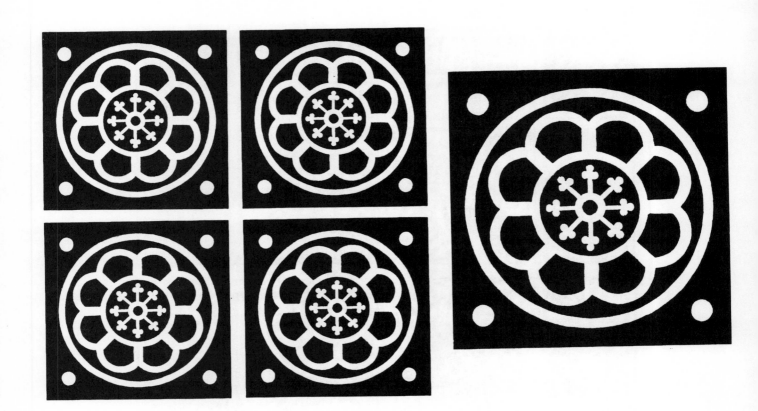

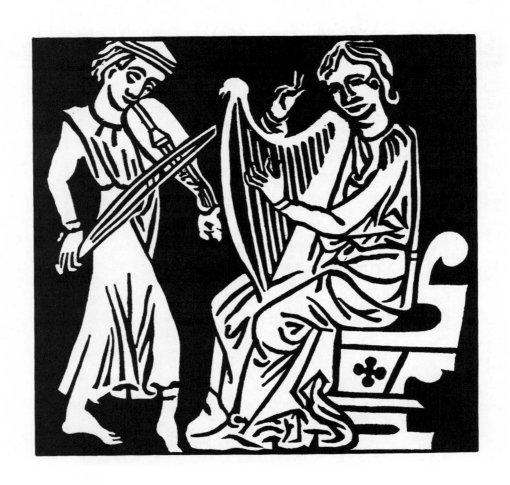

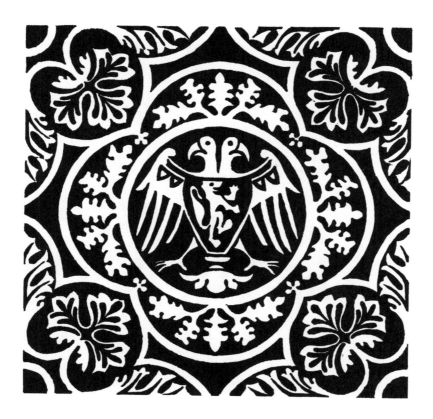

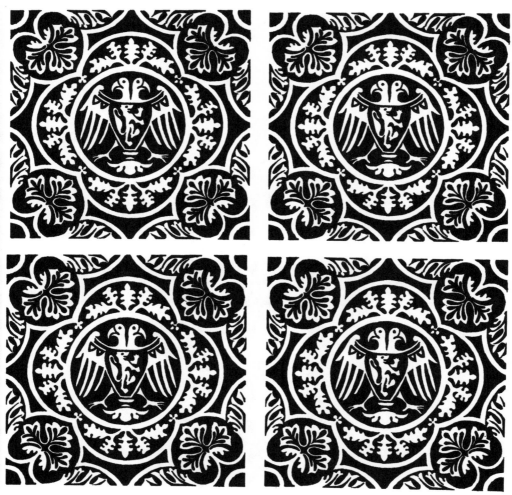

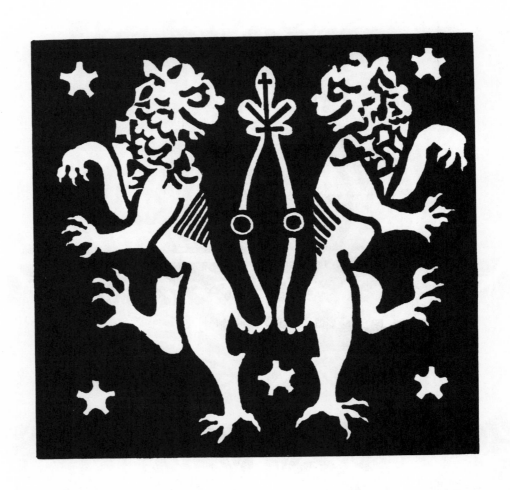

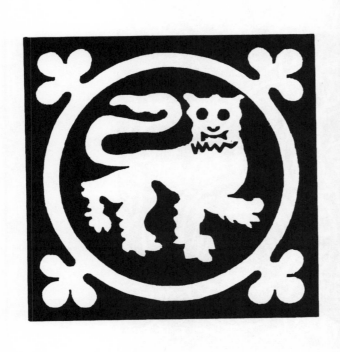

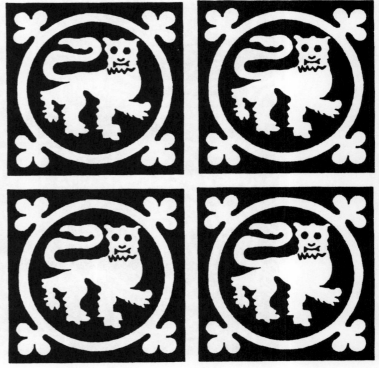

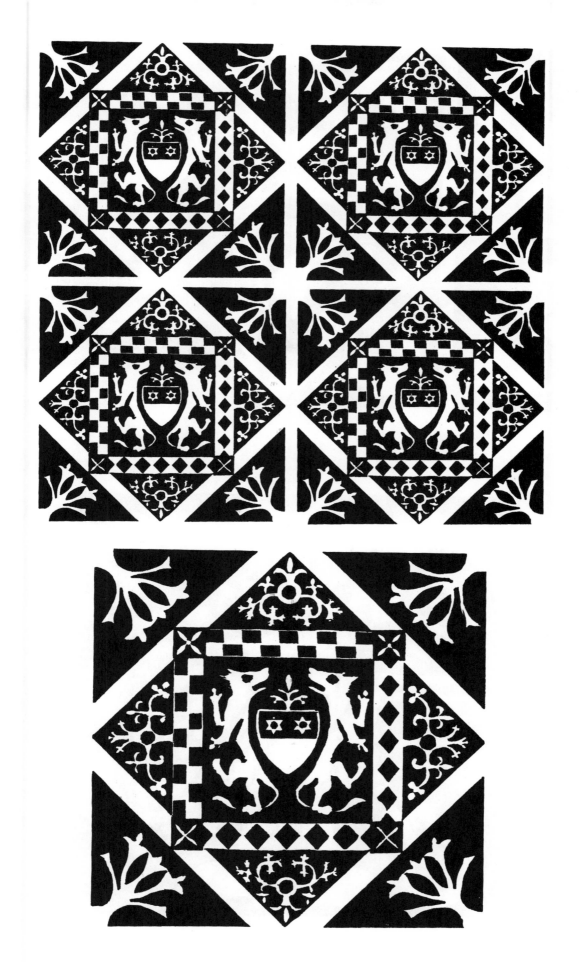

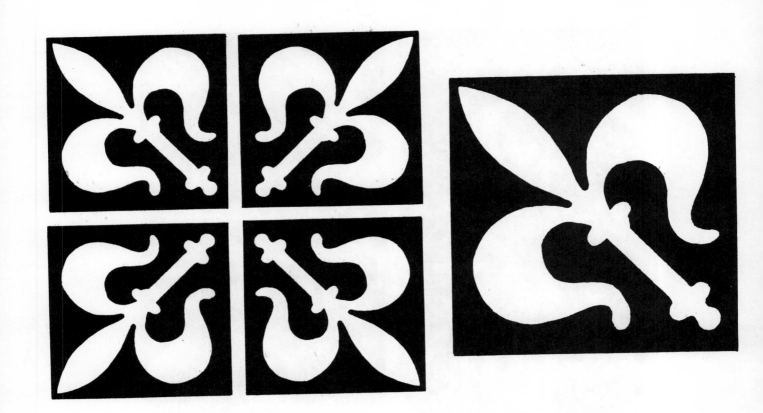

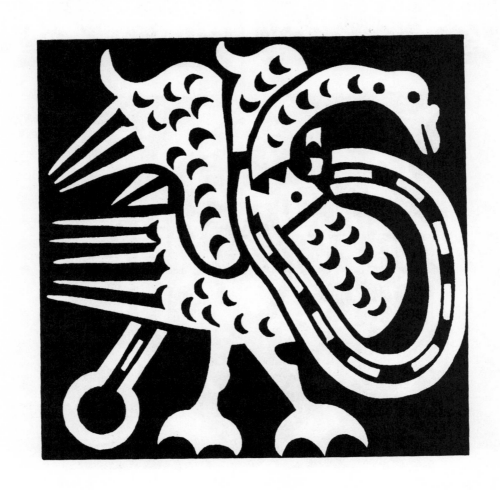

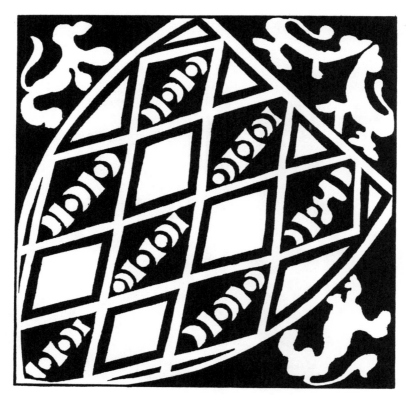

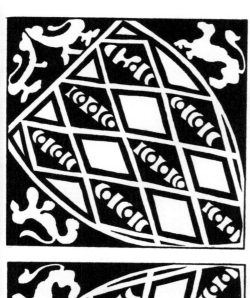
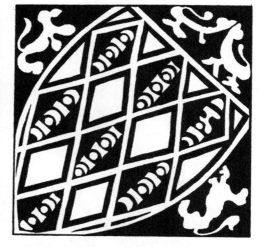

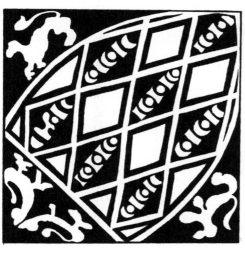
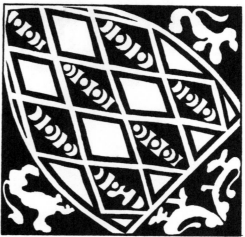

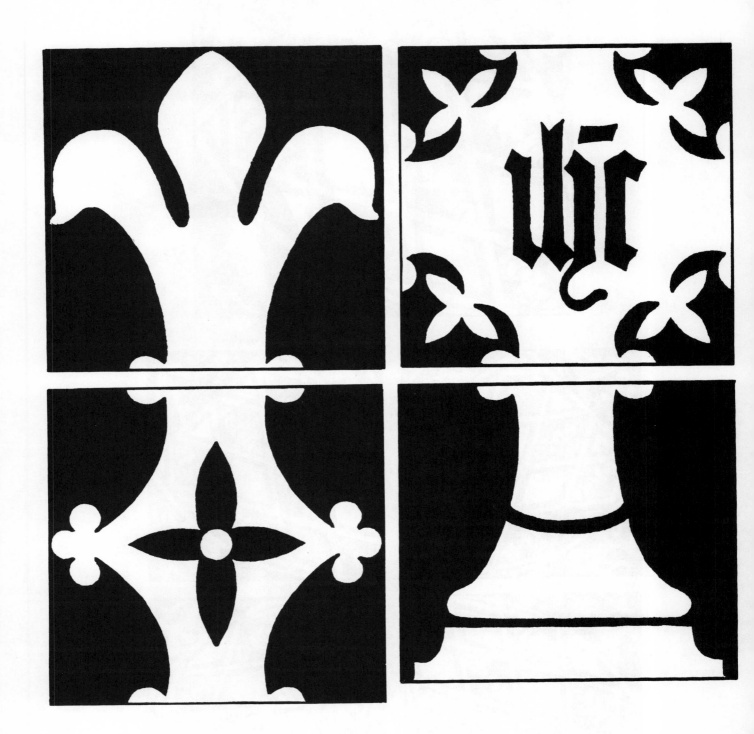

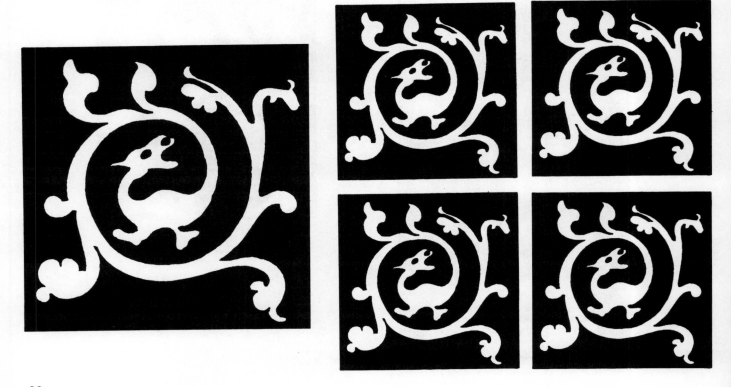

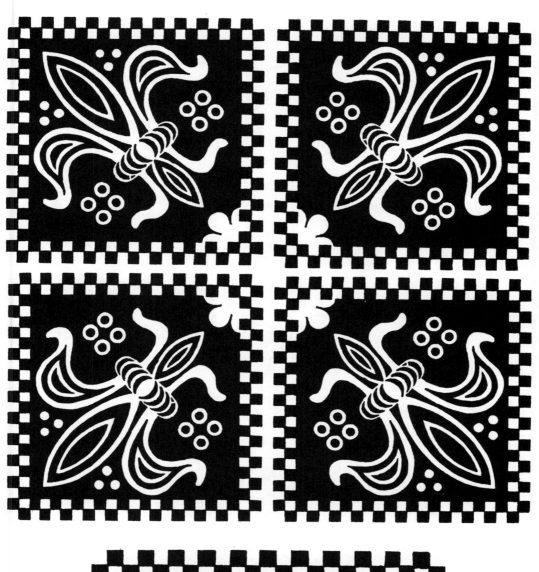

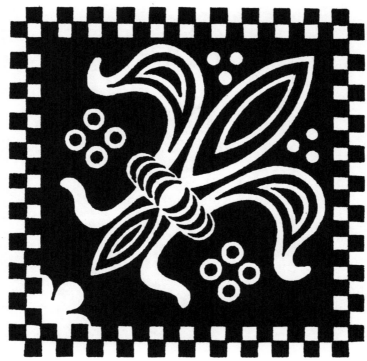

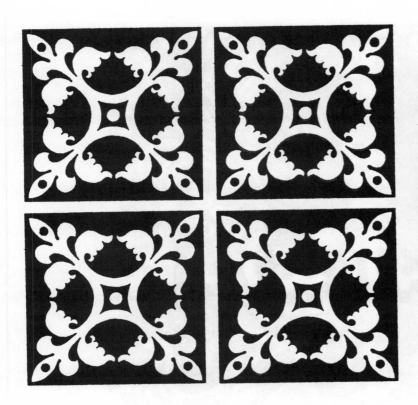
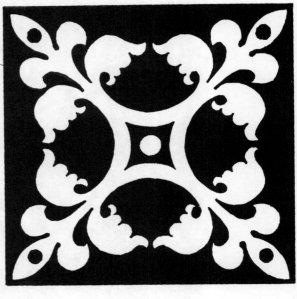
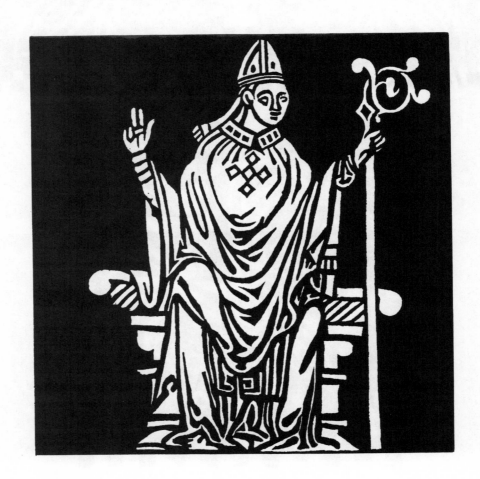

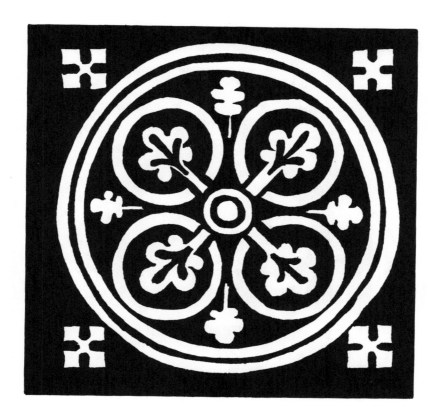

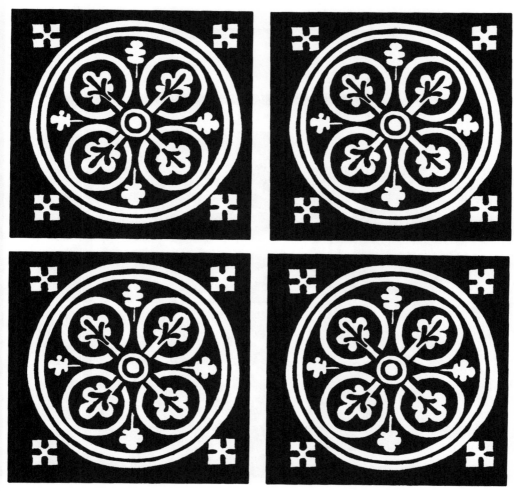

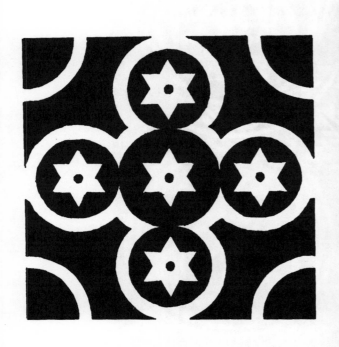

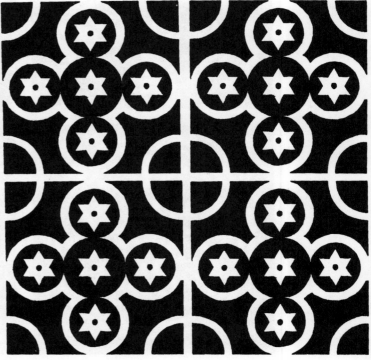

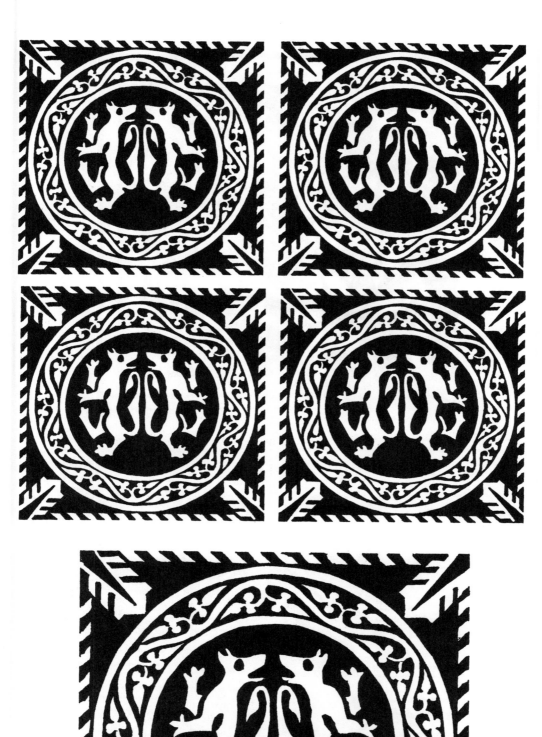

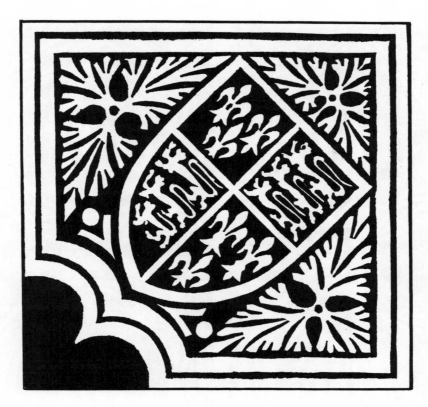

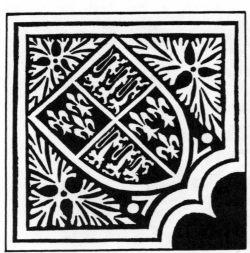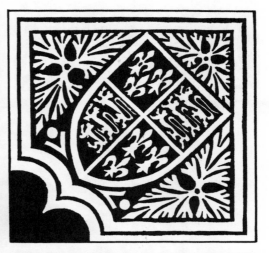

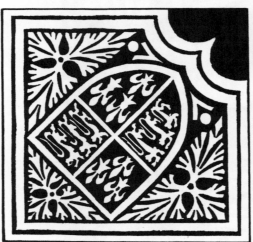

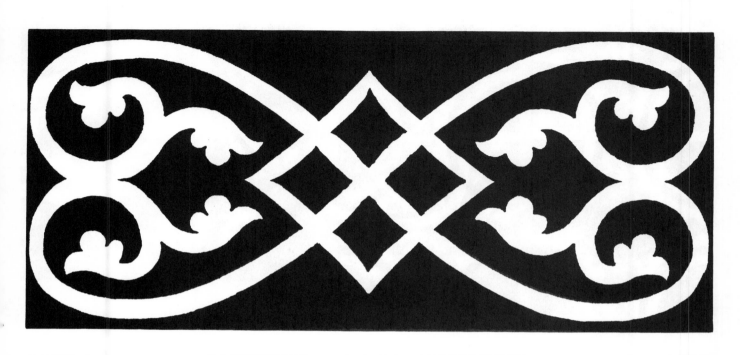

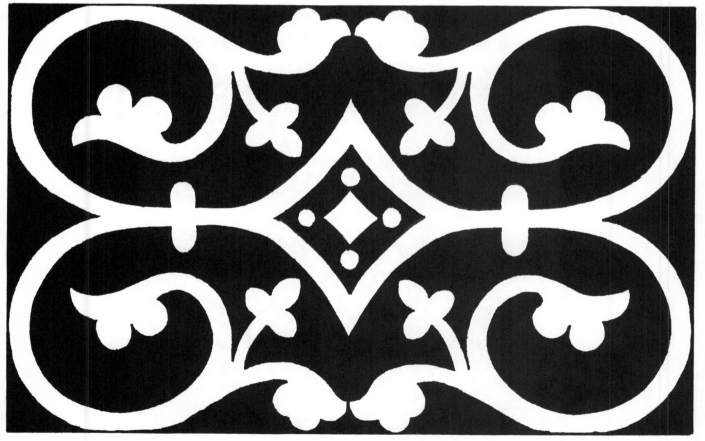

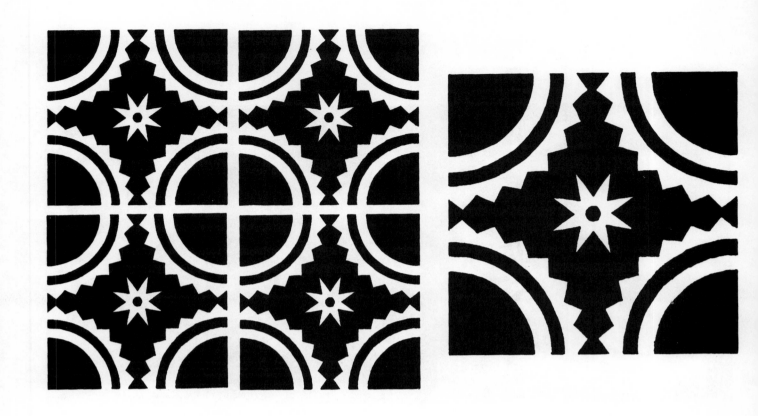

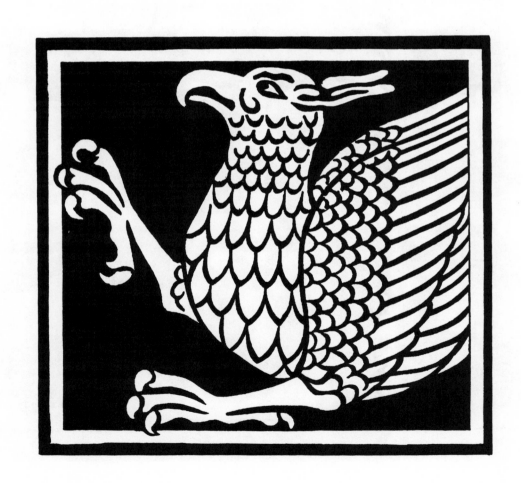

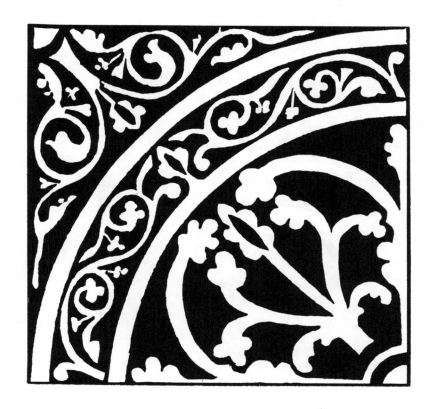

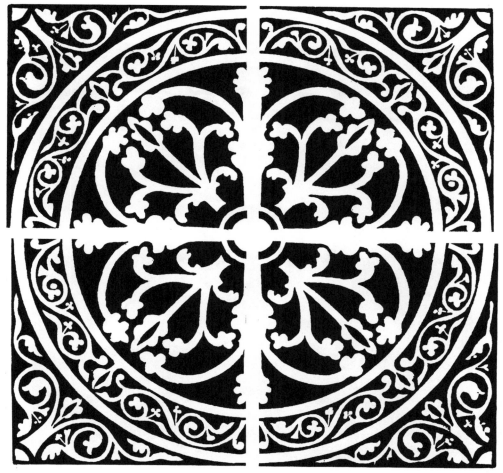

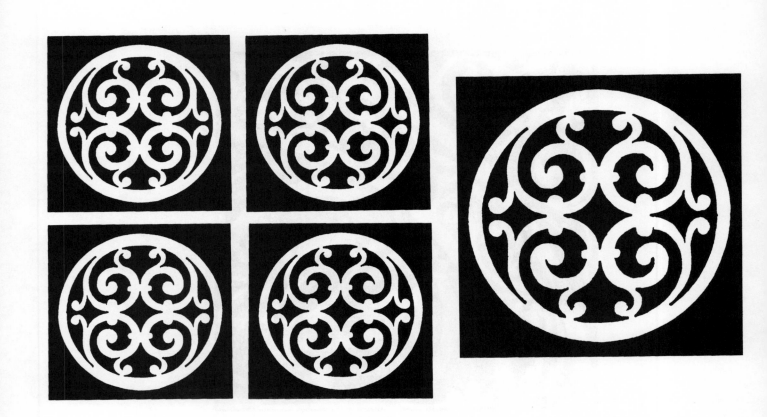

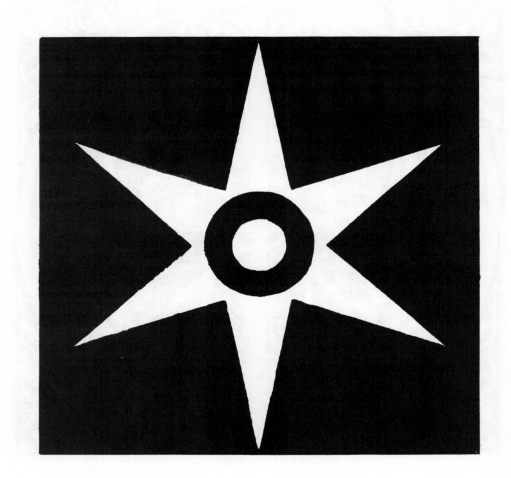

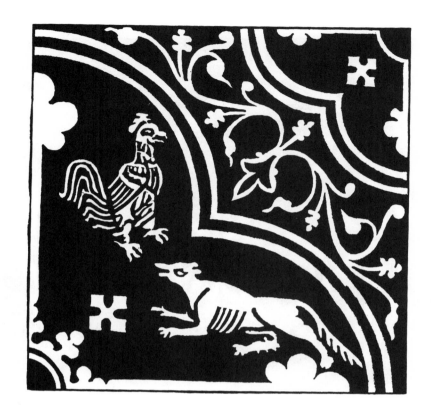

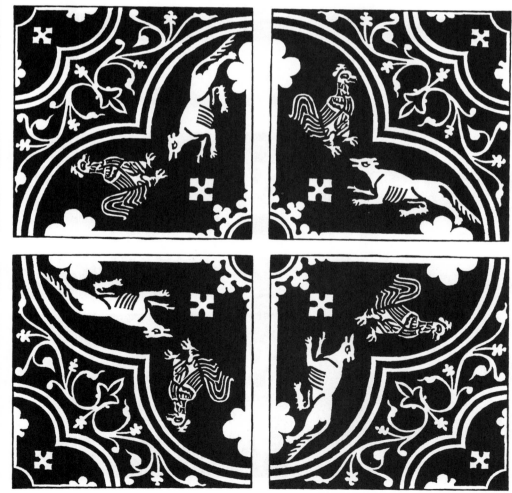

43

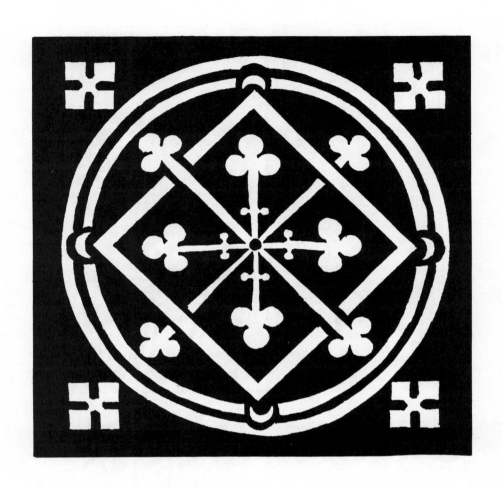

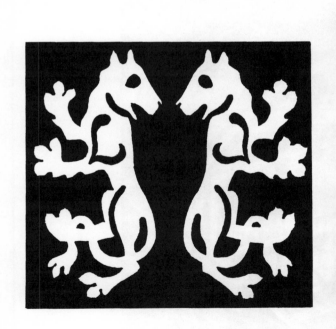

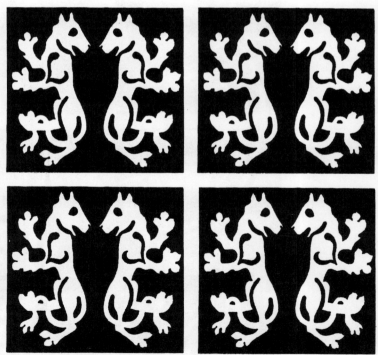

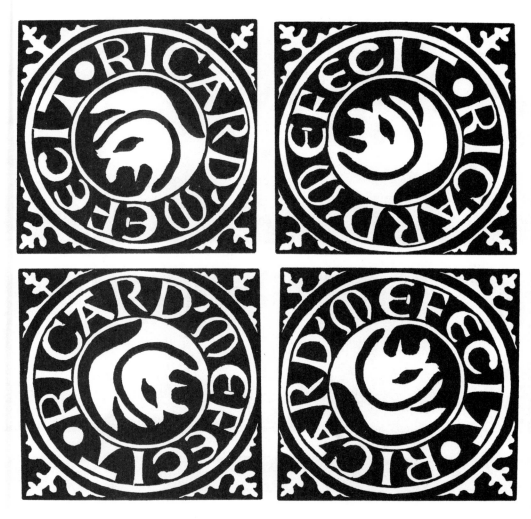

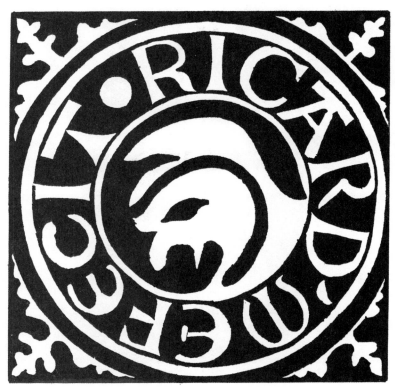

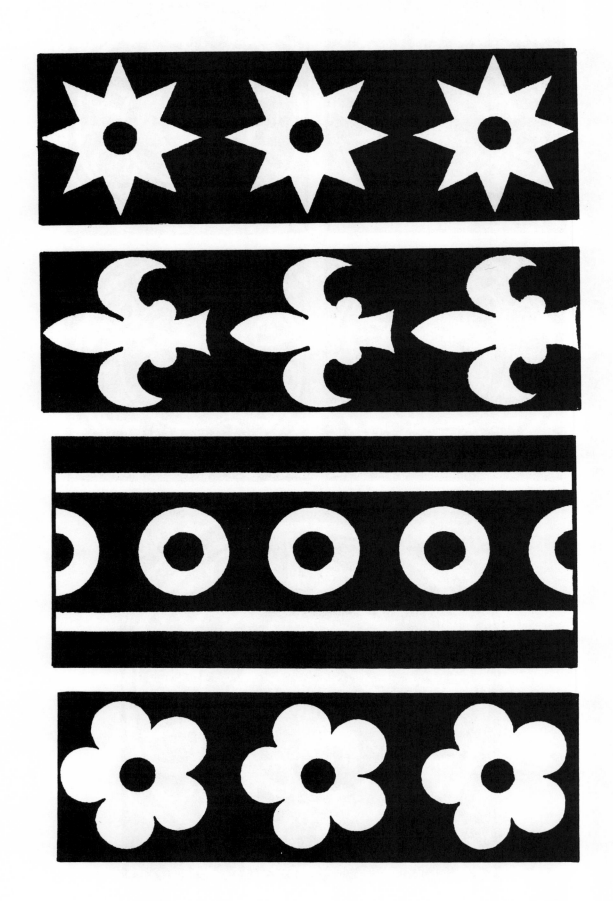

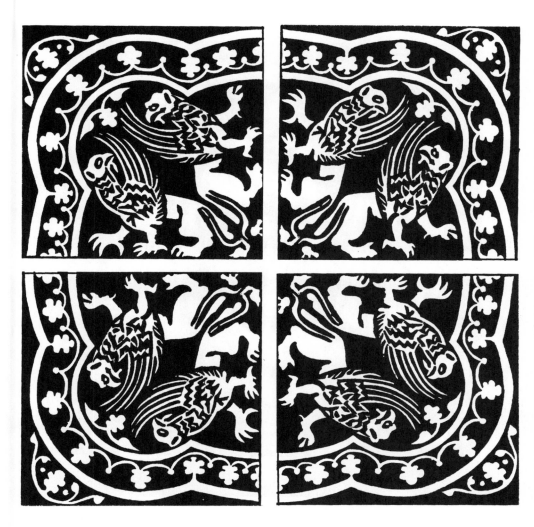

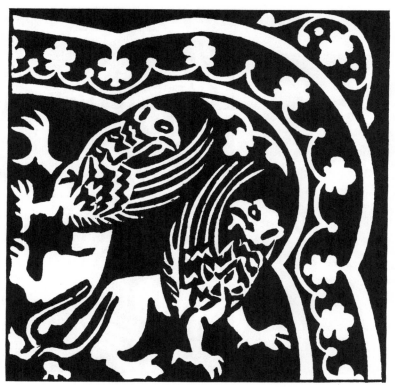

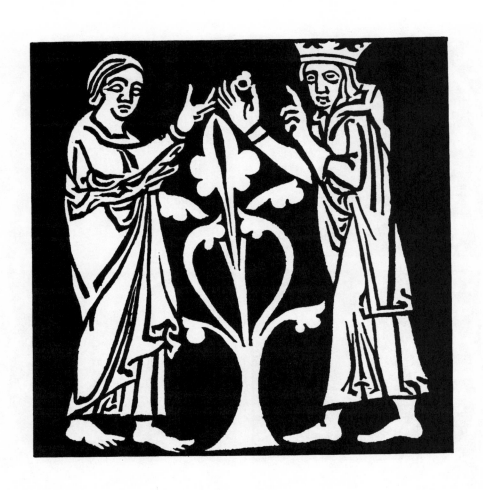

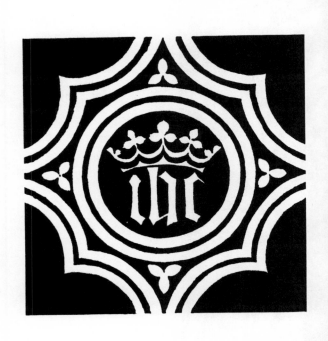

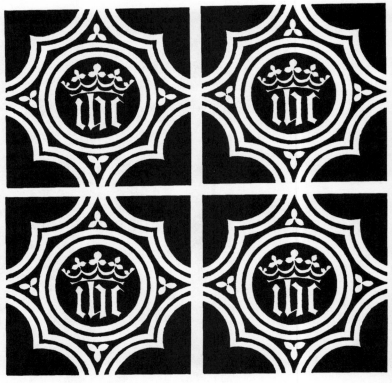

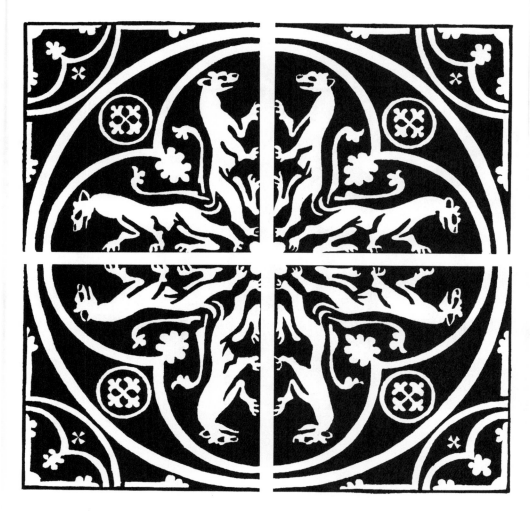

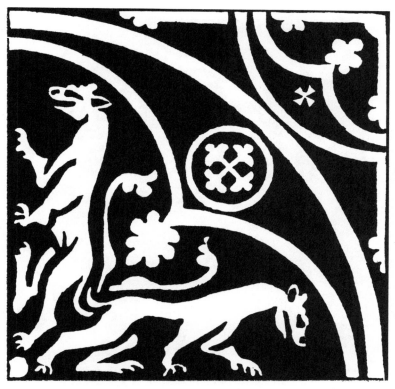

49

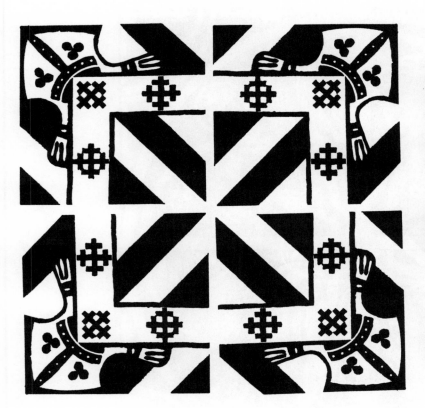

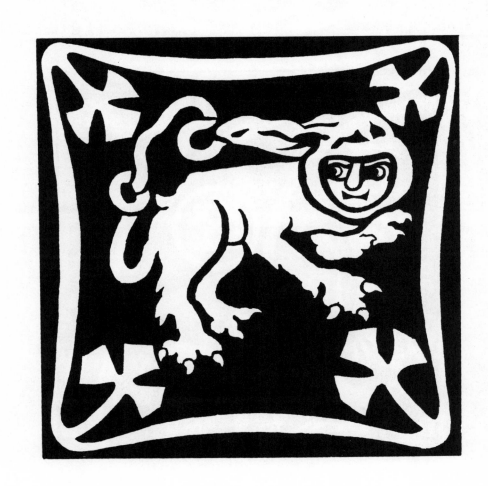

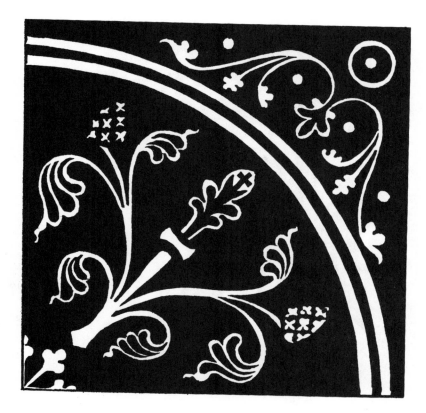

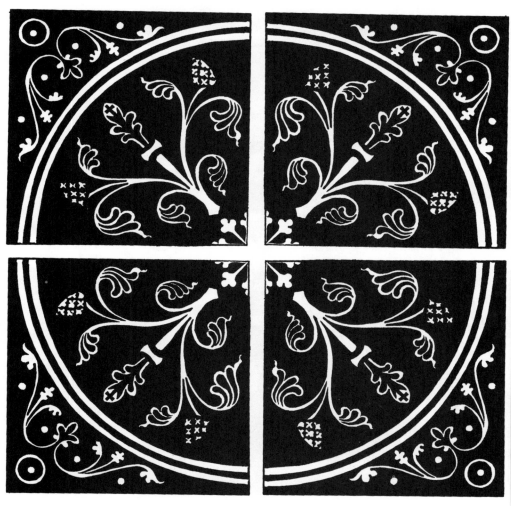

51

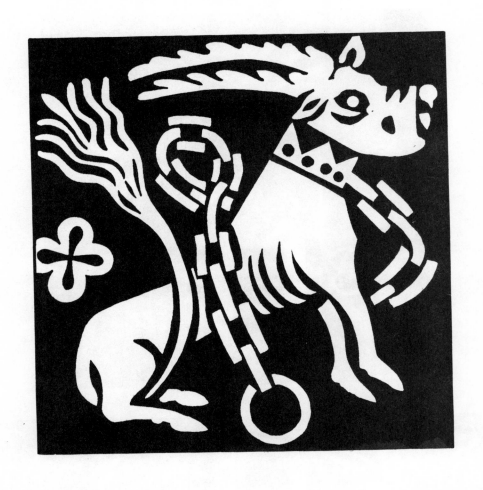

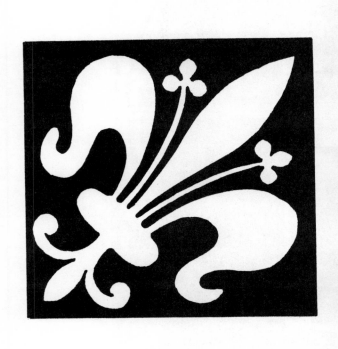

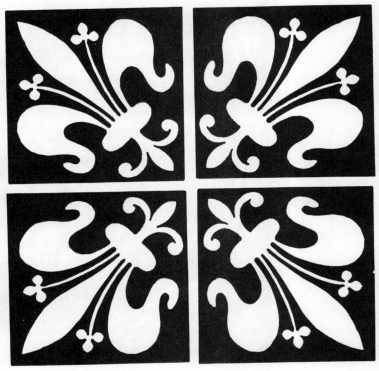

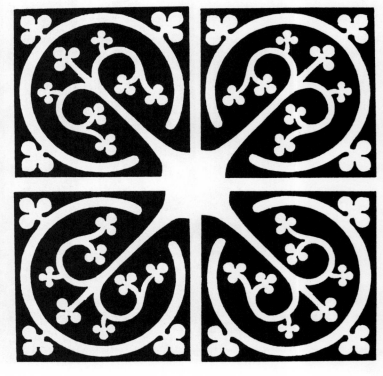

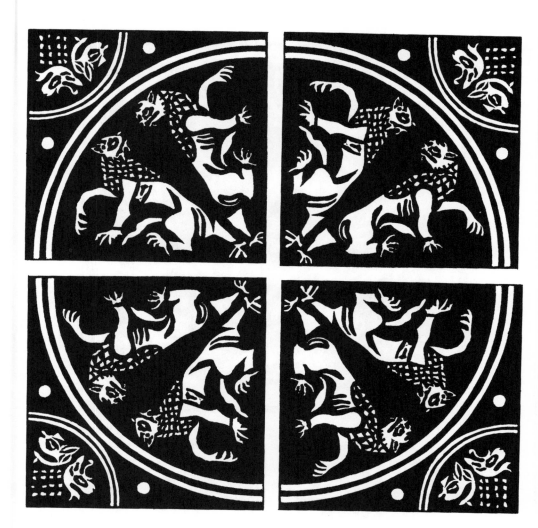

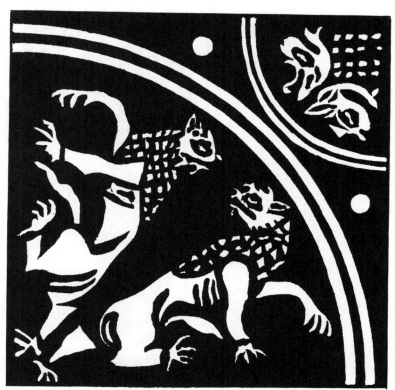

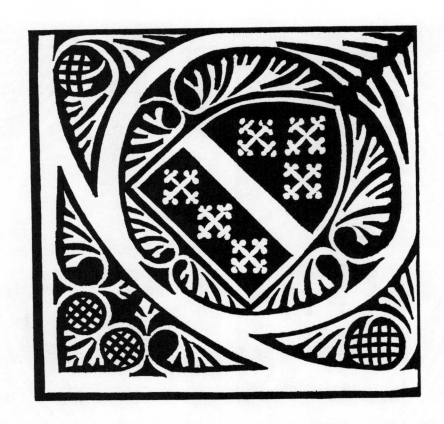

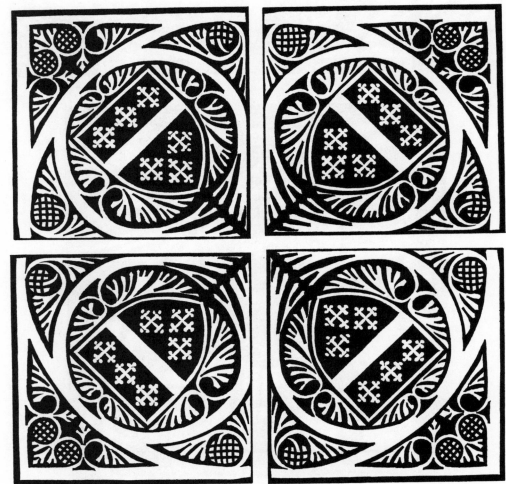

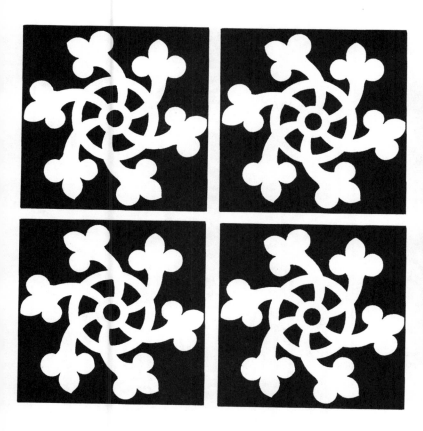

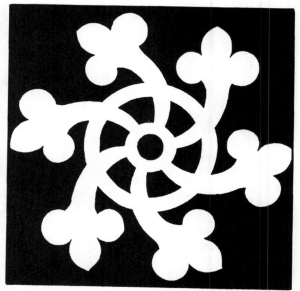

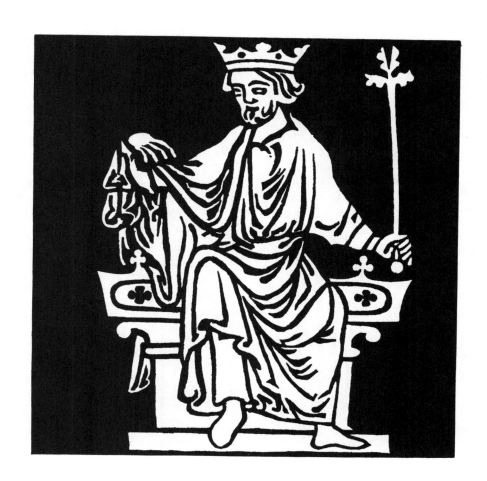

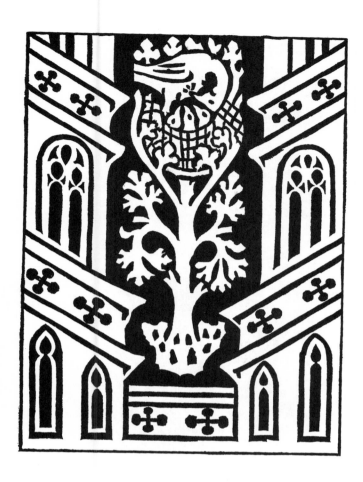

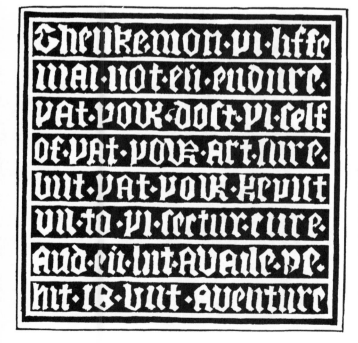

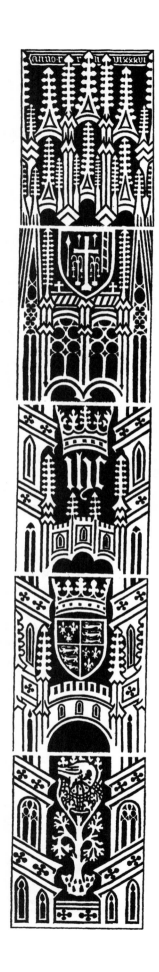

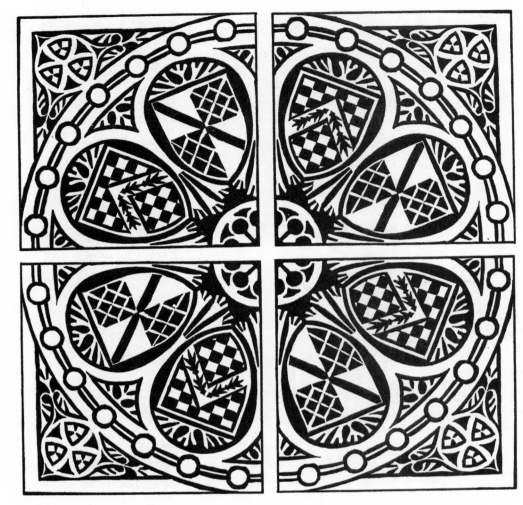

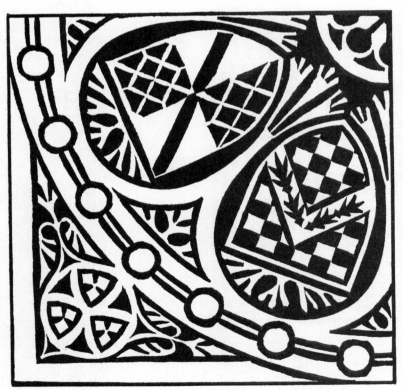